W A L

D E N

IN THE
WESTERN
RESERVE

A Photographic
Essay
by Jennie Jones

Concept and
thoughts by
Manny Barenholtz

To my Bonnie, whose encouragement helped bring Walden to its full bloom.

MANNY BARENHOLTZ

In loving memory of my mother Leah.

*With gratitude for the professional beginnings
inspired by my father Jonas,*

*And appreciaton for the supporting
shoulder of my Aunt Esther.*

WALDEN, *a tribute to the devotion of their life careers--*
Bill Schuster,
Paul Tiber,
Bernie Adkins,
and to the design and inspiration of
Architect, William B. Morris.

MANNY BARENHOLTZ

there was only a dream...a vision of the perfect
environment for daily living...where one
could commune with nature and refresh the soul.

In 1970 the dream began to come true on nearly
one thousand acres of lovely land in the heart of
Ohio's Western Reserve.

We called it Walden, harking back to that earlier
Walden of Henry David Thoreau where nature ruled.
The inspiration was found in Thoreau's credo for
happiness in daily living: "Simplify, Simplify."

Hills and valleys...lakes and streams...forests
and meadows became the backdrop for our country
homes of soft and natural architecture, part of
the land itself. Even the recreational amenities
that add to the pleasures of life in Walden were
planned as a part of its natural beauty.

The photographs that follow tell of the continuing
realization of the Walden dream.

Enjoy the story.

Architecture that blends into nature
can inspire people as much as
it enhances the way they live.

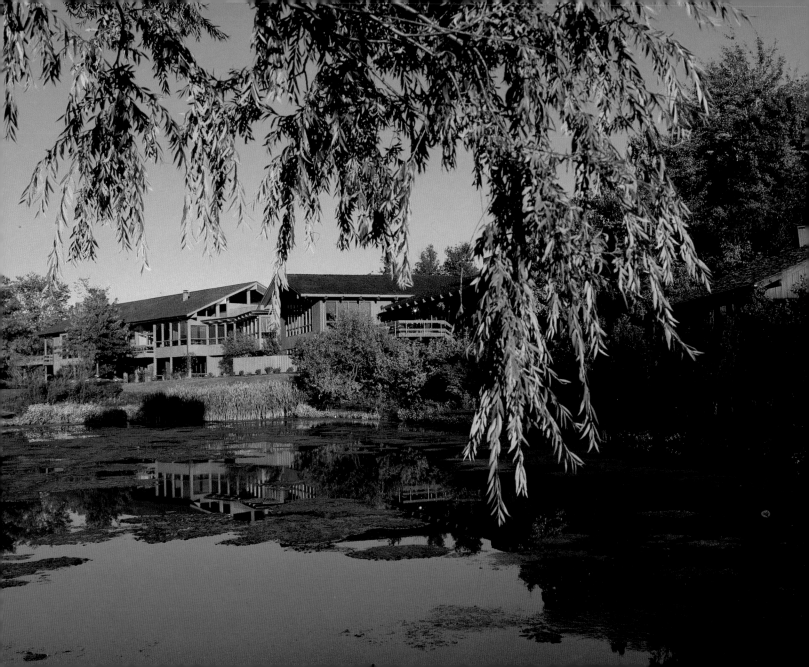

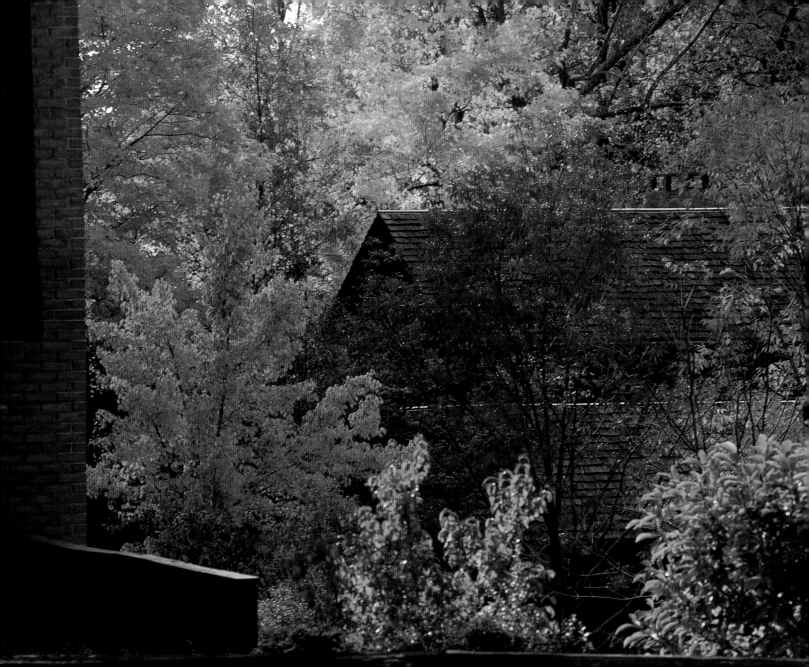

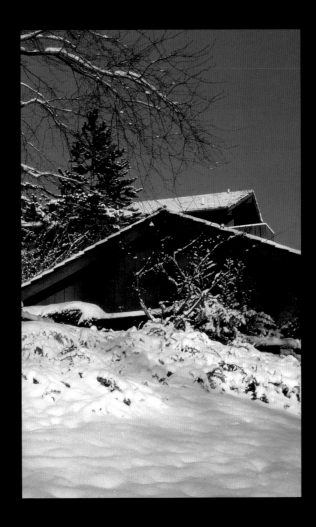

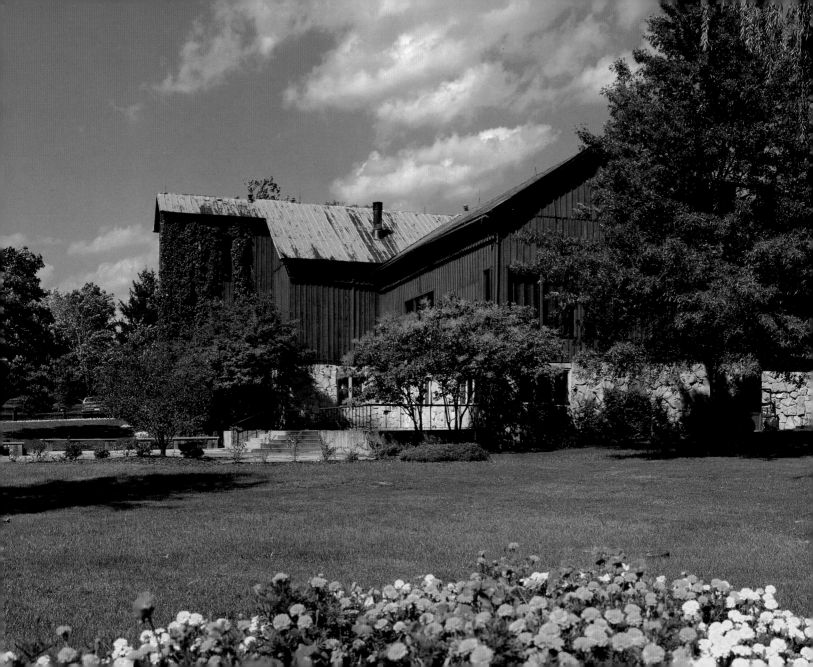

The timeless simplicity
of an old barn, restored,
remaining to inspire.

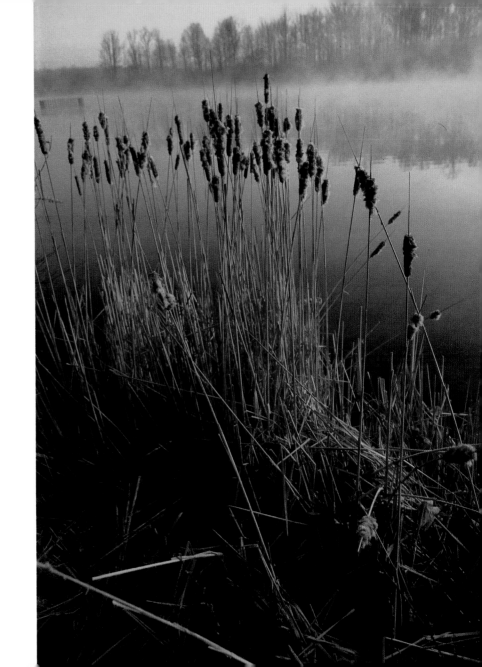

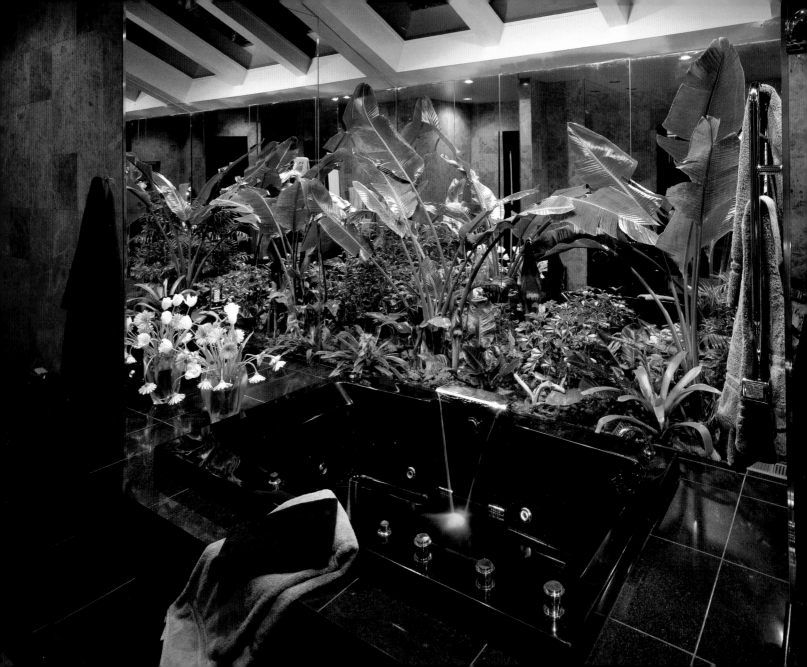

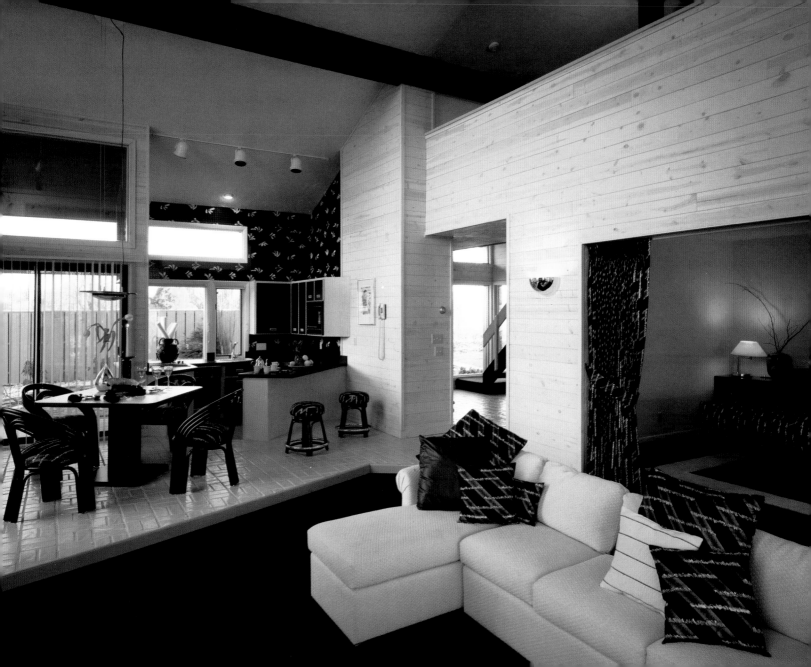

*Homes, like the people
we love, should be
honest and sincere.*

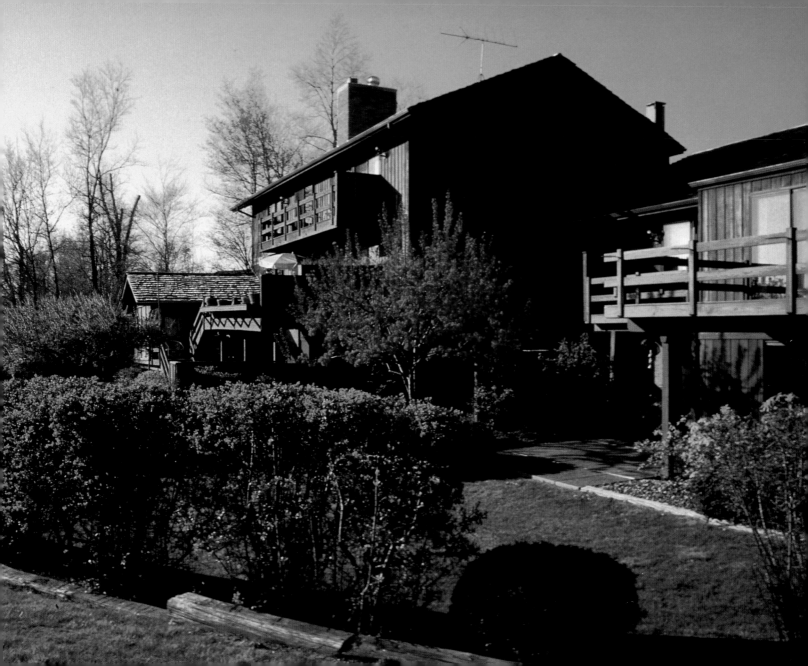

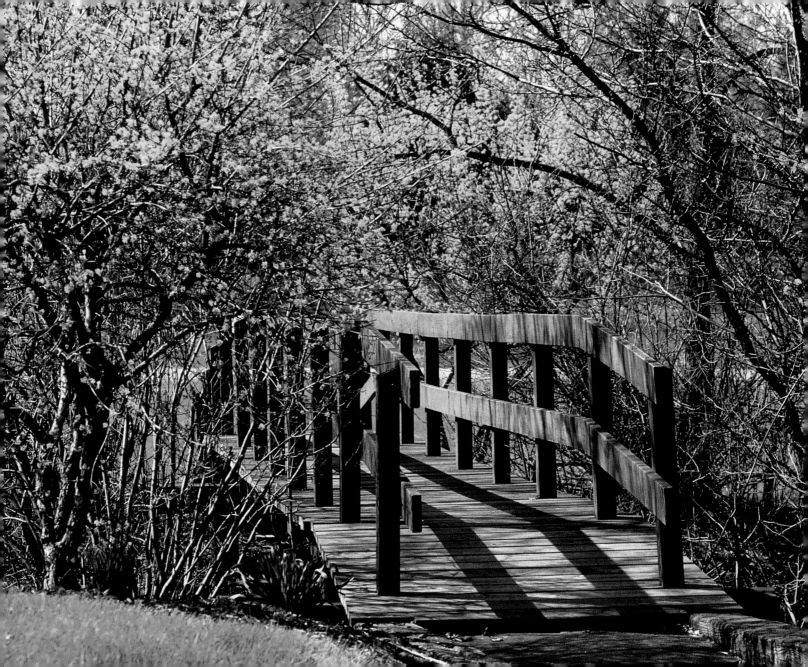

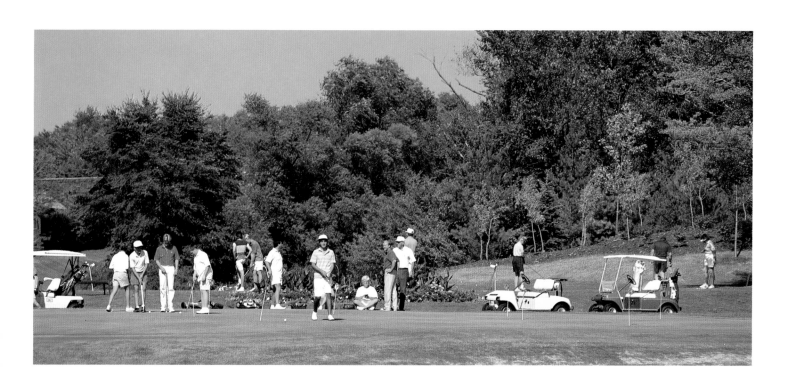

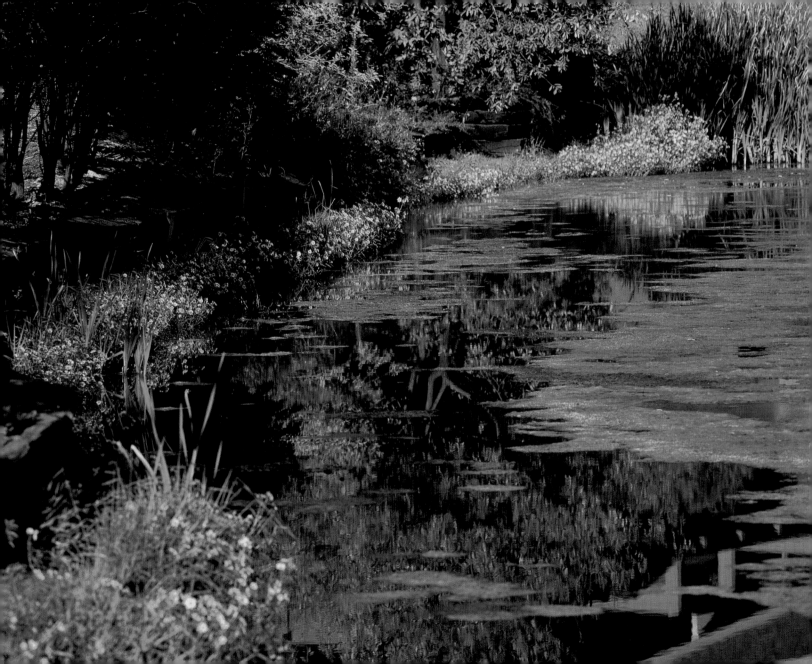

Beauty cannot be verbalized nor the elation it elicits.

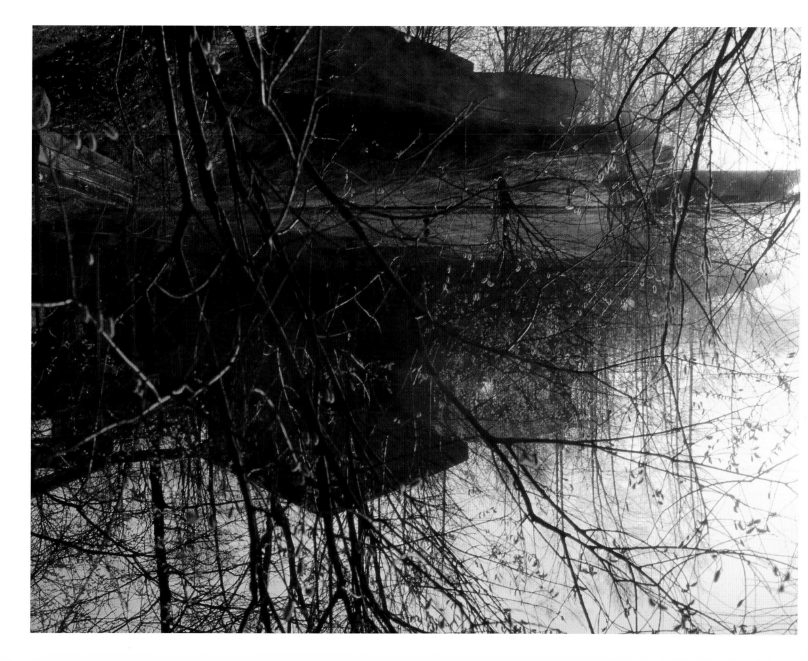

*Nature, herself,
is the garden.*

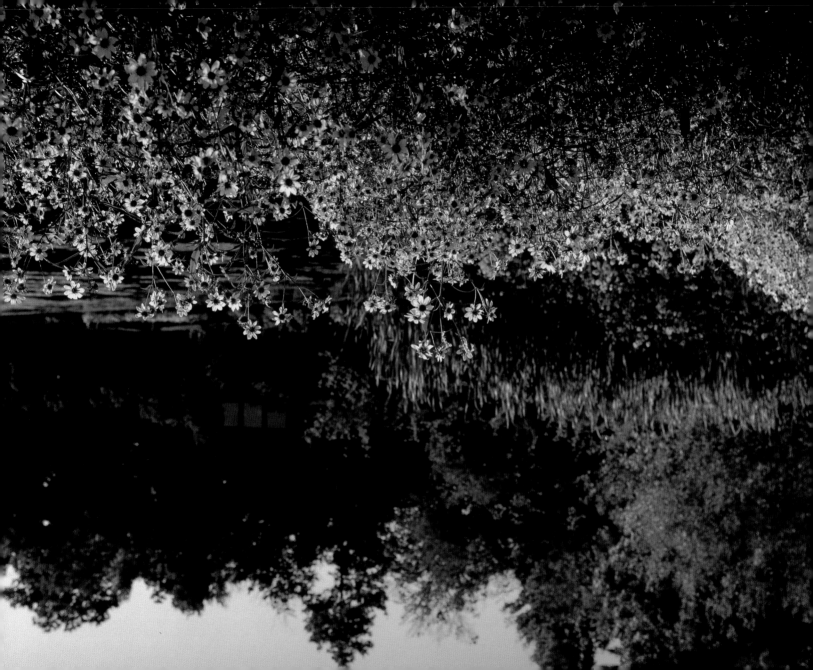

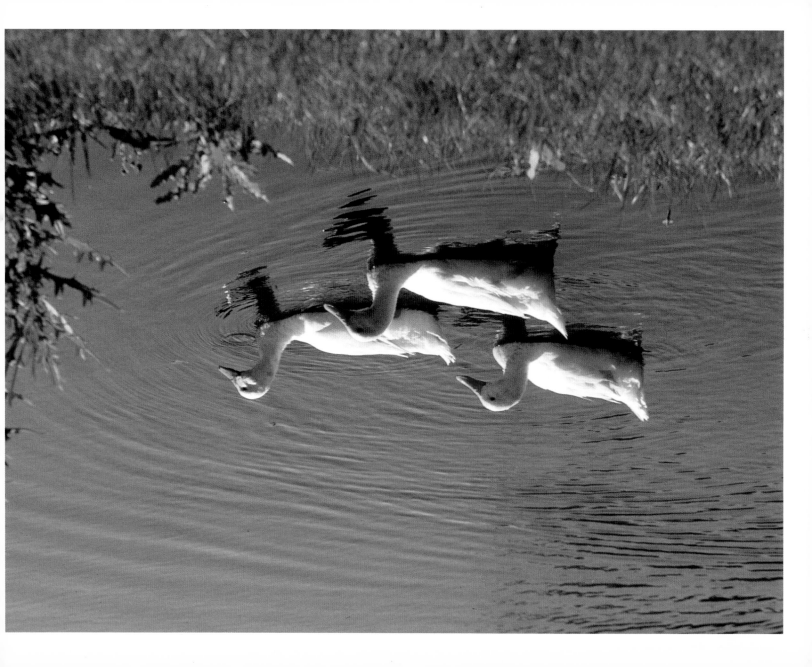

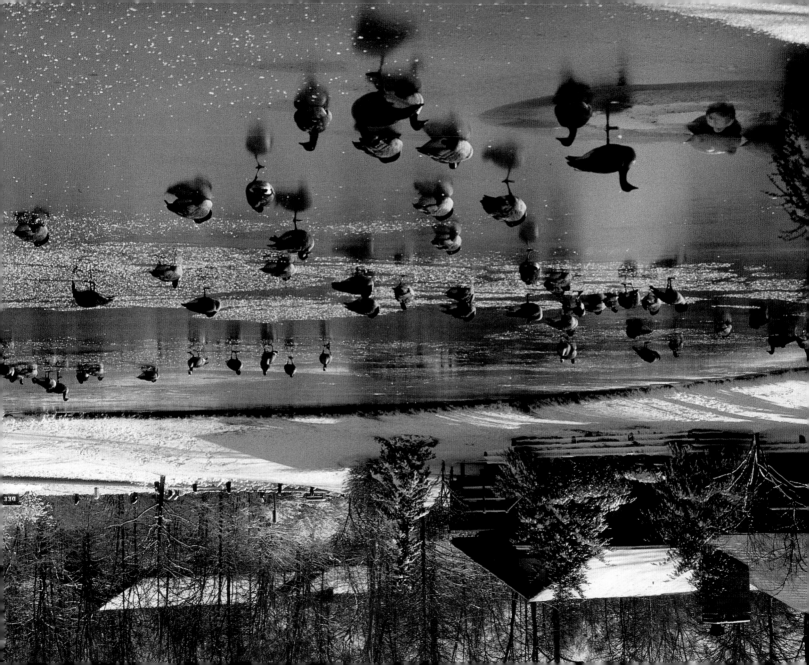

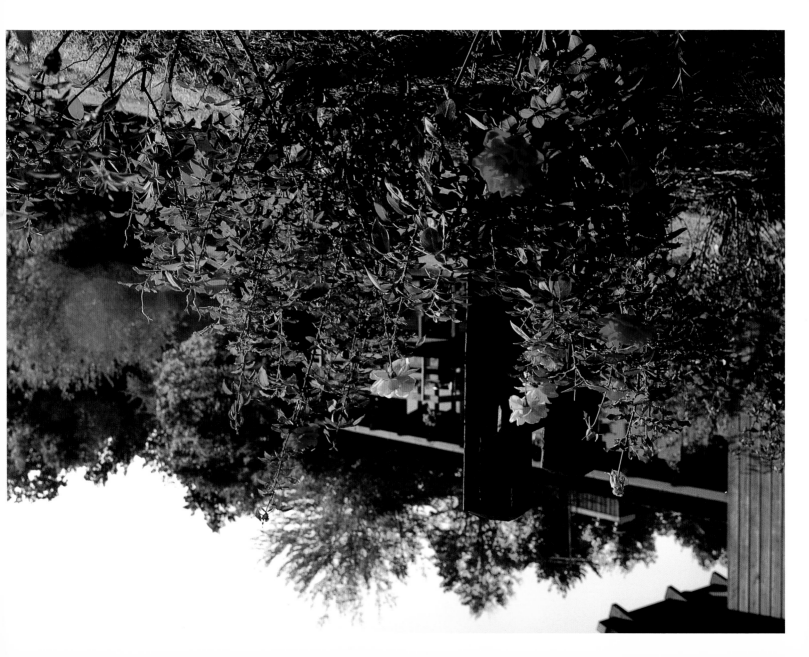

Rustic materials,
as they age and mellow,
bring Walden ever
closer to nature.

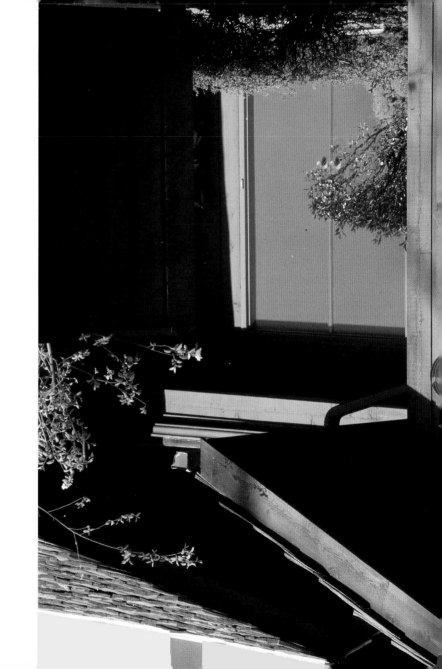

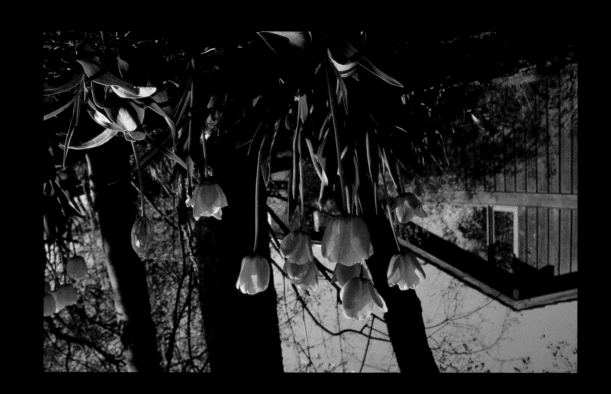

A poetry of repose,
Springtime.

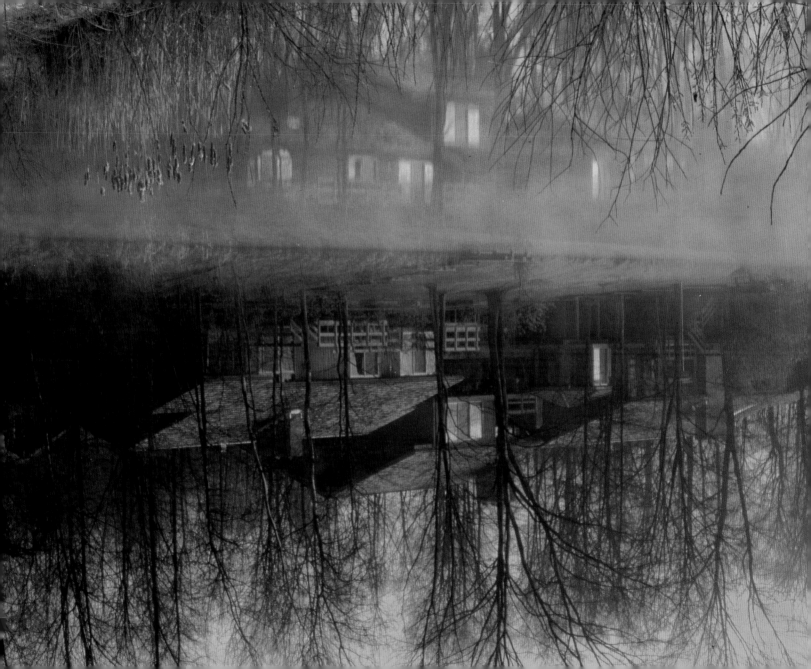

Restrained elegance.
Quiet. Comfortable. Simple.

Nature approached with reverence,
is a source of regeneration and
a mystical experience.

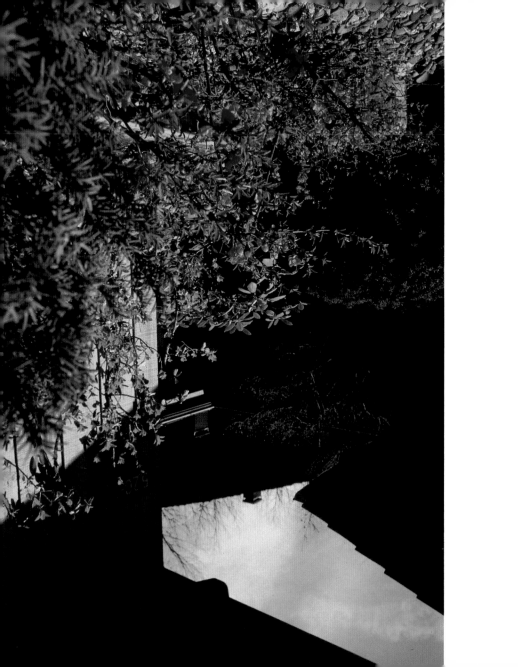

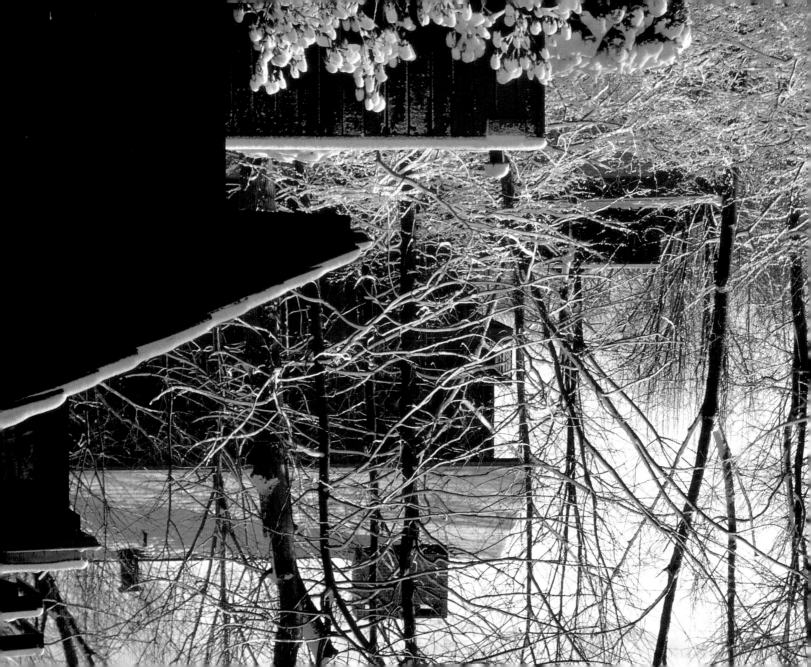

A country house,
a retreat for every season.

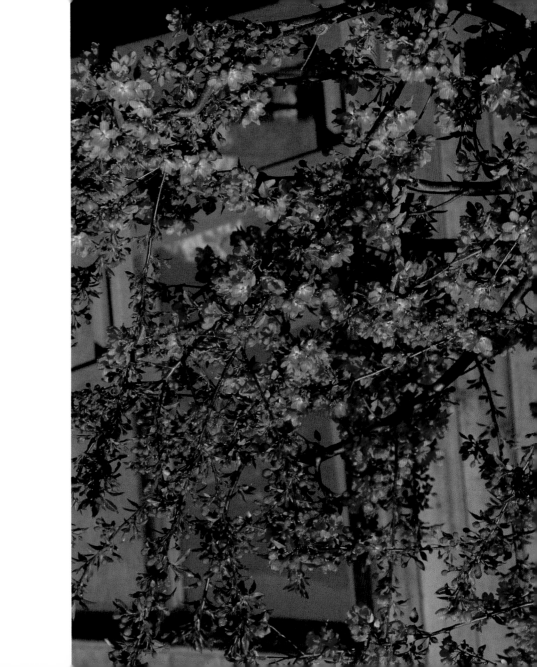

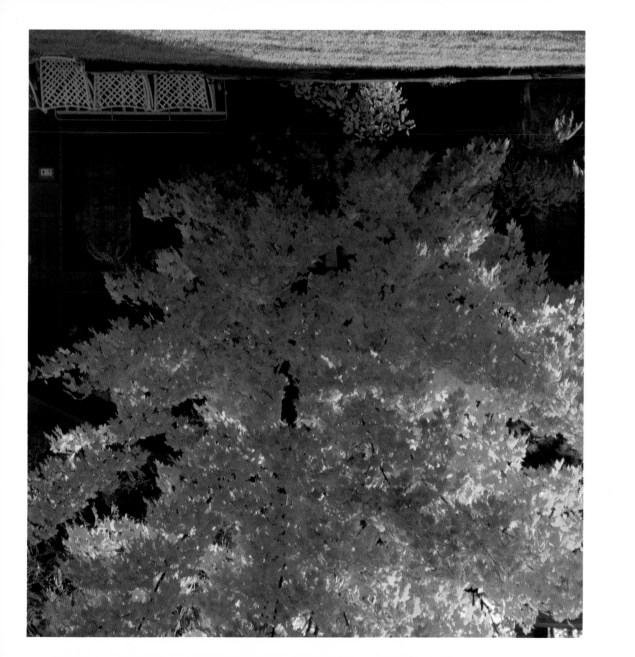

As night falls, the house becomes a great lantern in the forest.

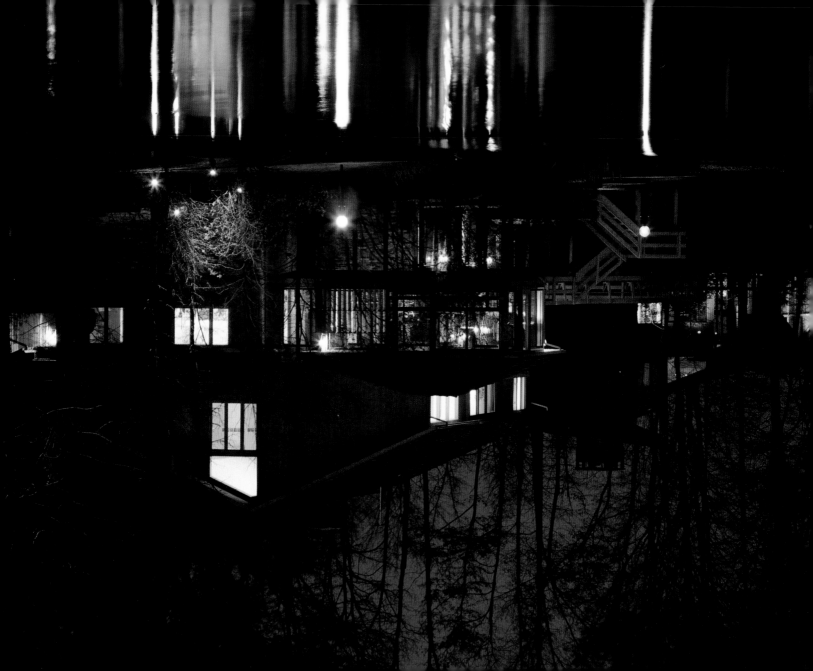

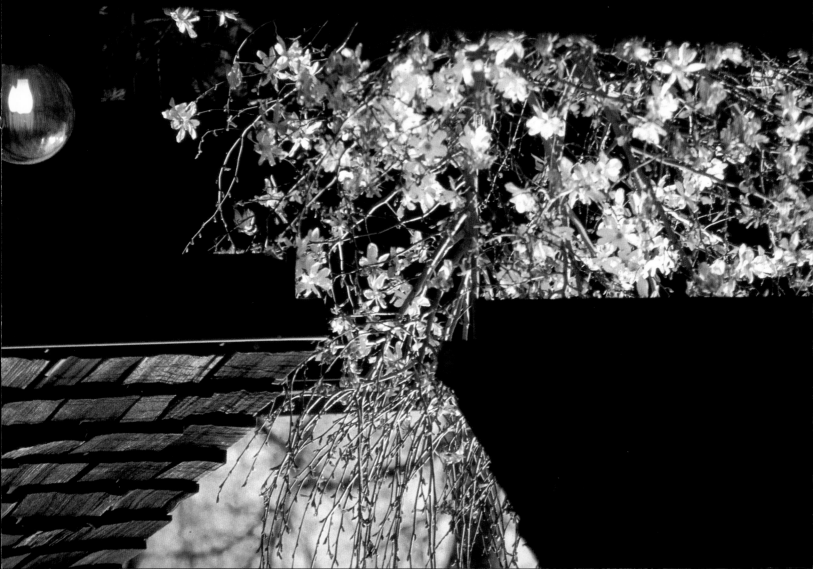

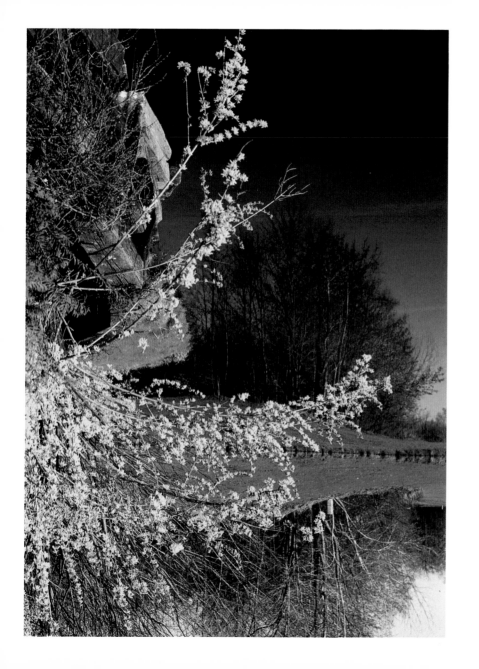

Rough cedar shakes
and the beauty of
blossoming dogwoods.

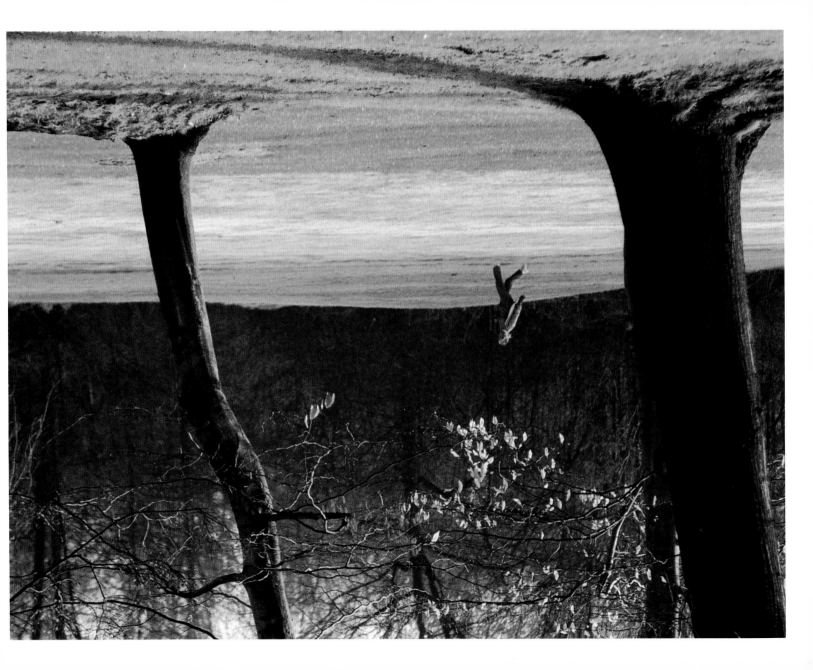

Clean sparkling air.
Refreshing. Exhilirating. Invigorating.

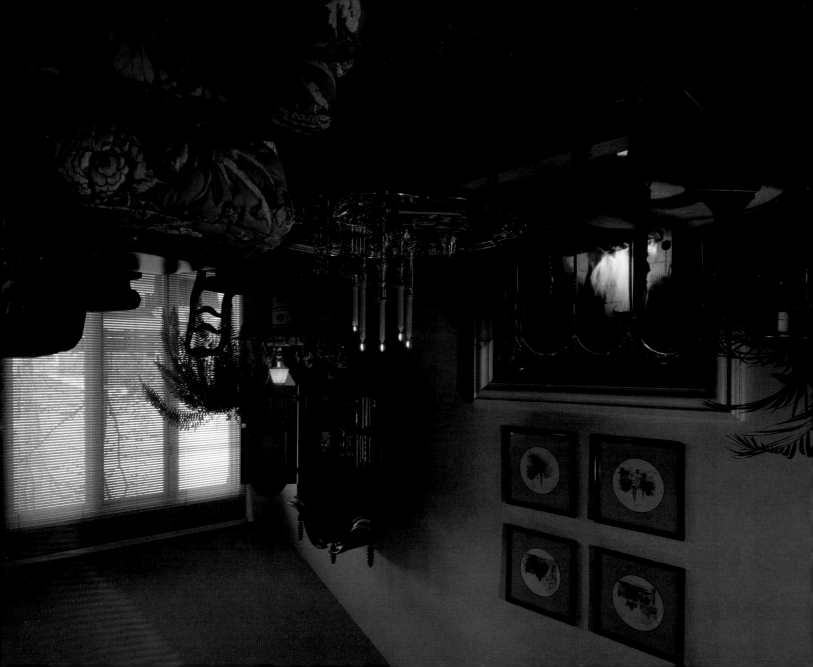

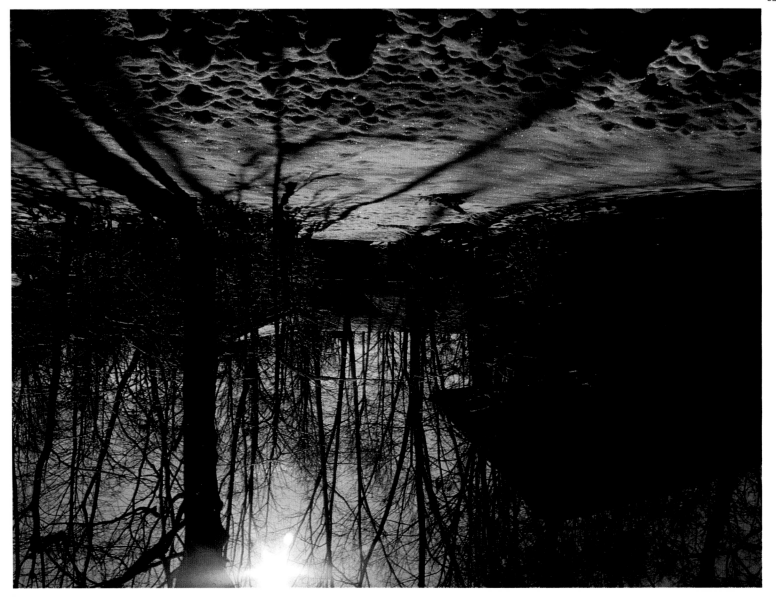

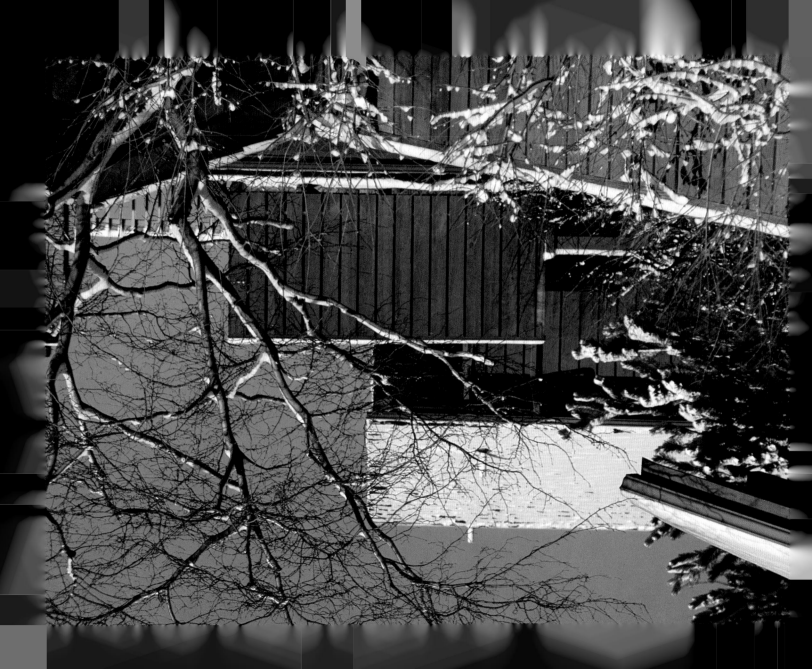

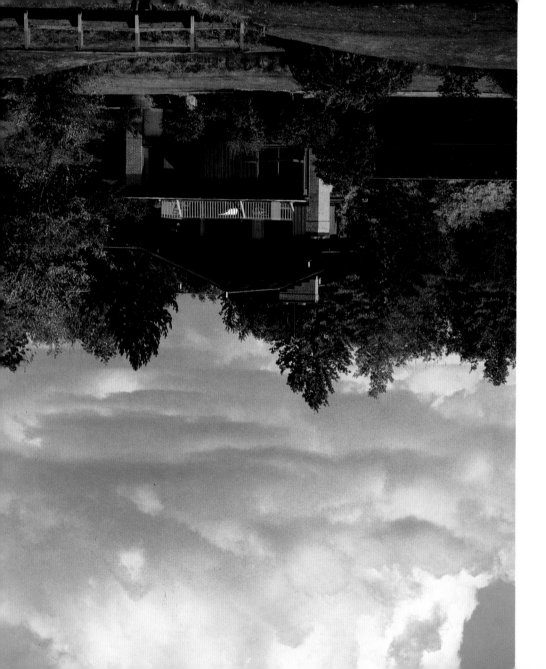

How comforting,
in a world of shifting values,
to discover a haven of stability.

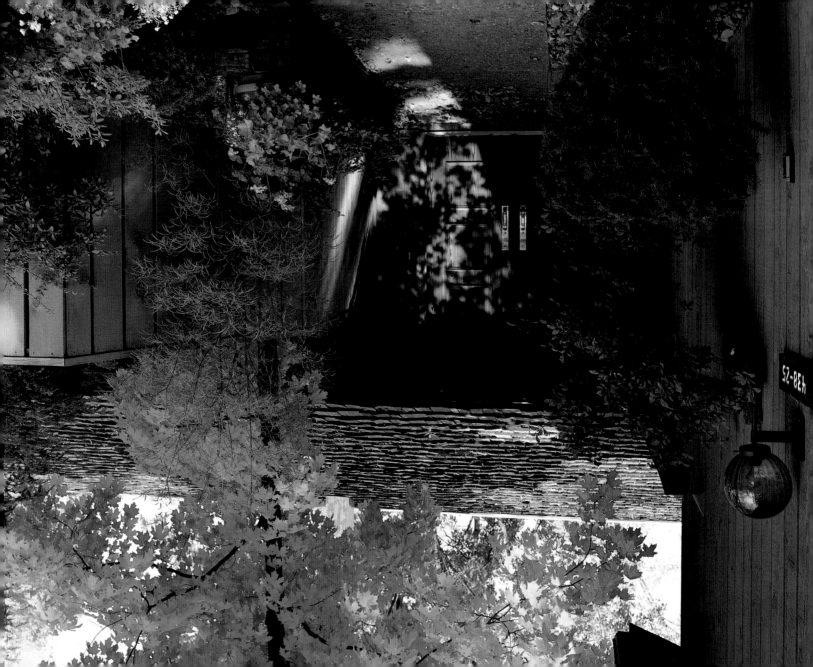

Gently sloping roofs, quiet
skylines, sheltering overhangs,
and walls that reach out
to sequester private gardens.

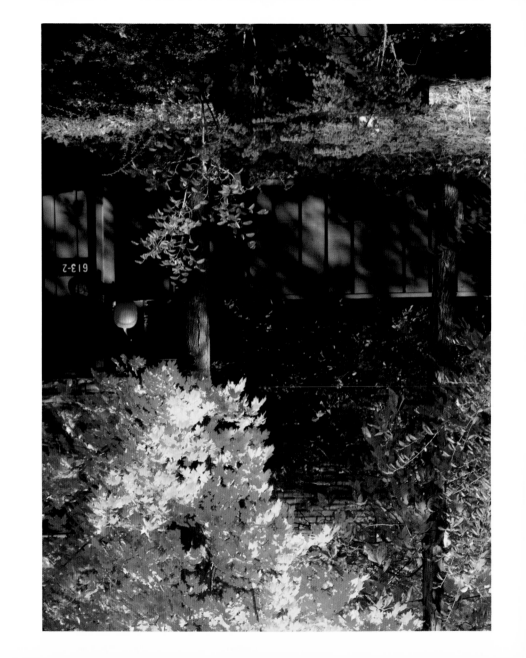

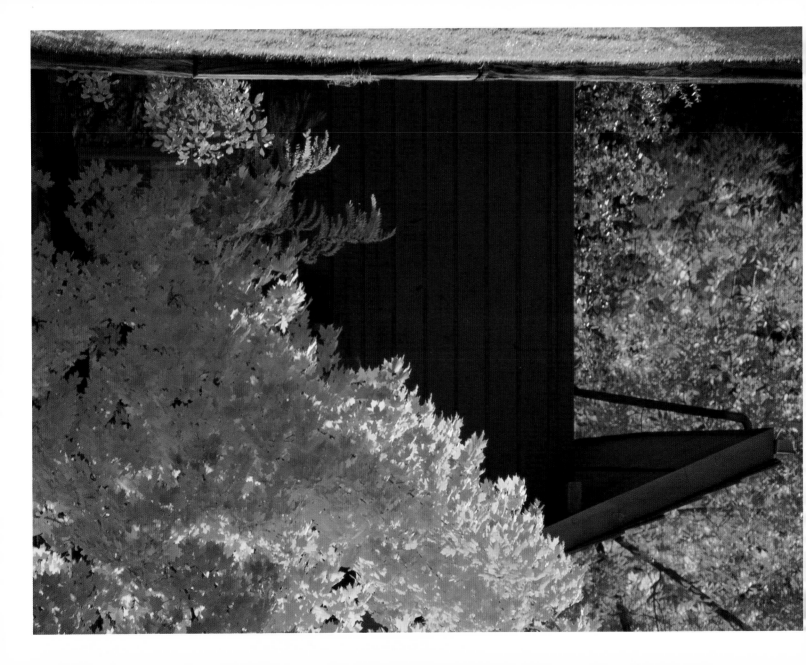

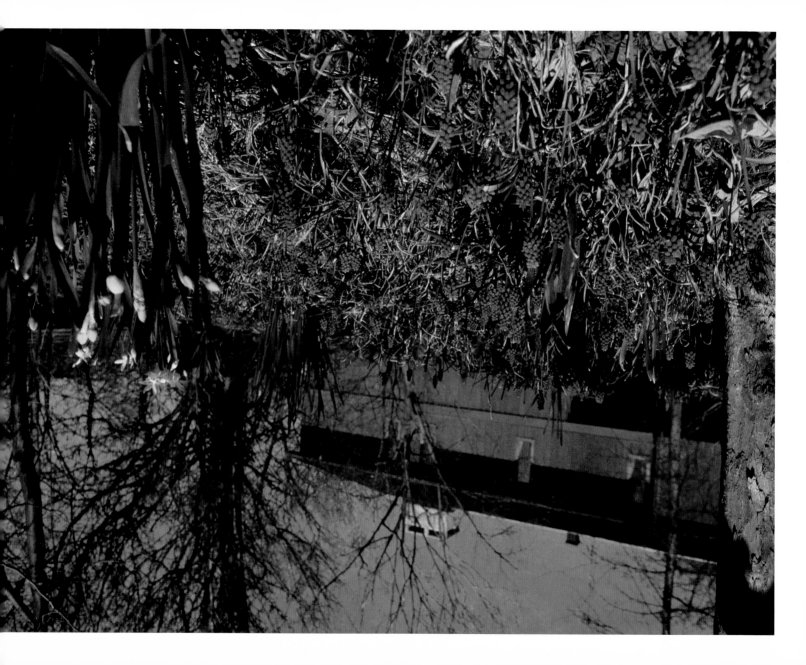

Changing seasons,
an everchanging background.

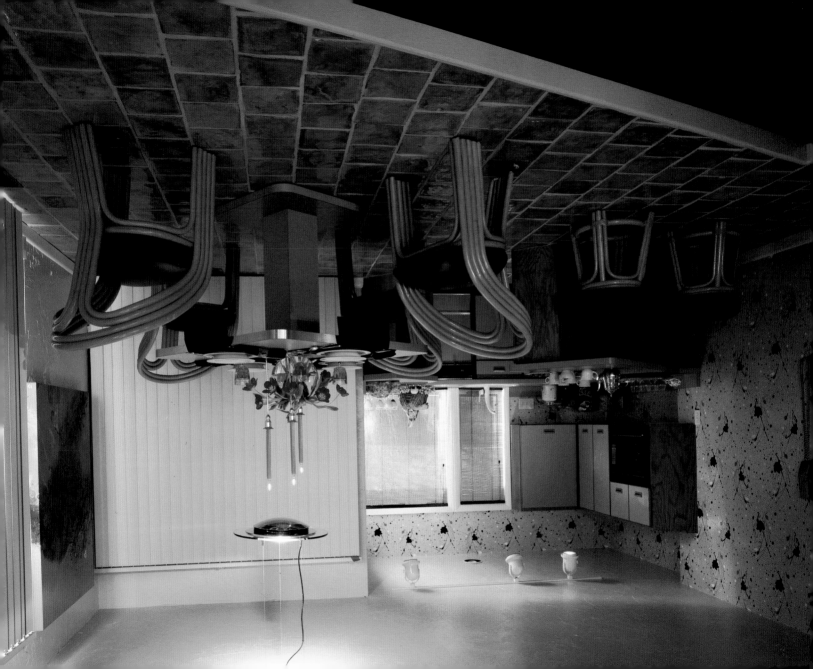

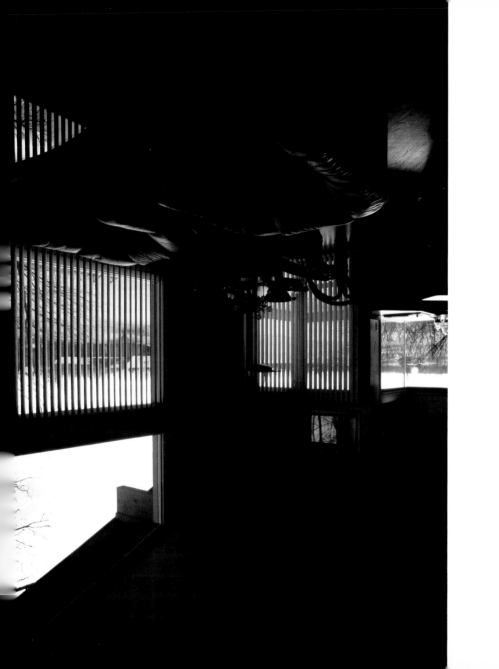

A soothing blend of superb lodgings, attentive service and fine cuisine.

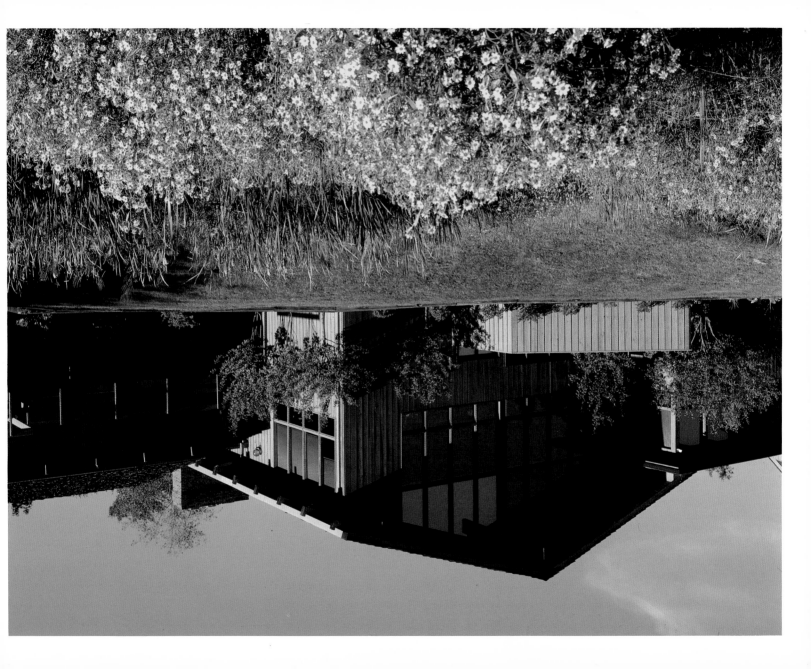

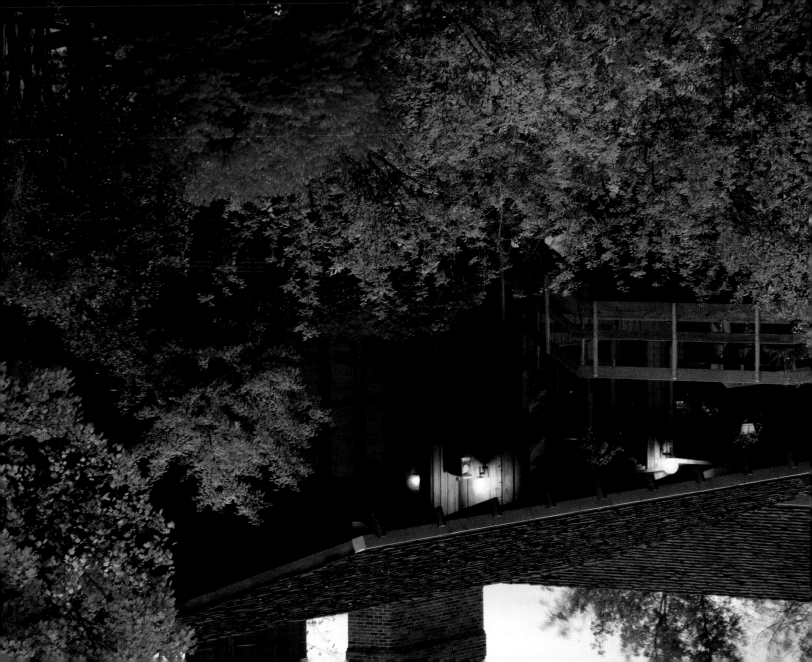

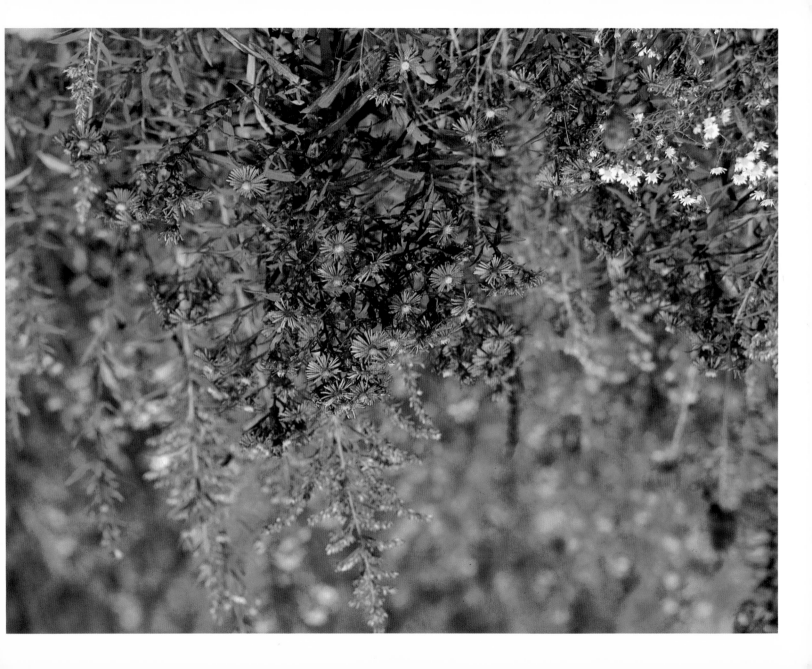

A world of quiet beauty.

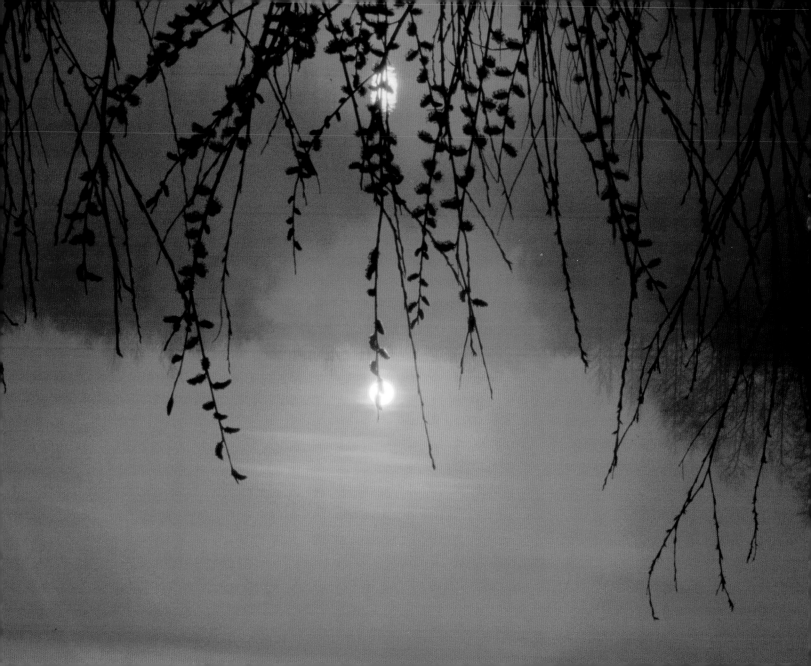

*Classic, understated beauty
where nature is the
developer's inspiration.*

Composition by John Szilagyi Inc.
in Adobe Linotype Palatino and Palatino Italic.
Type output on Linotronic 300.
Photos scanned on Dainippon Screen 608 Laser Scanner.
175 line separations.
Printed by The Emerson Press, Inc., Cleveland, Ohio
on a 28 x 40 Komori Lithrone 6 color press.
Paper is 80# Vintage Gloss Book.
Case bound by Forest City Bookbinding Company.